Painting Dragons
in
Watercolour

PAUL BRYN DAVIES

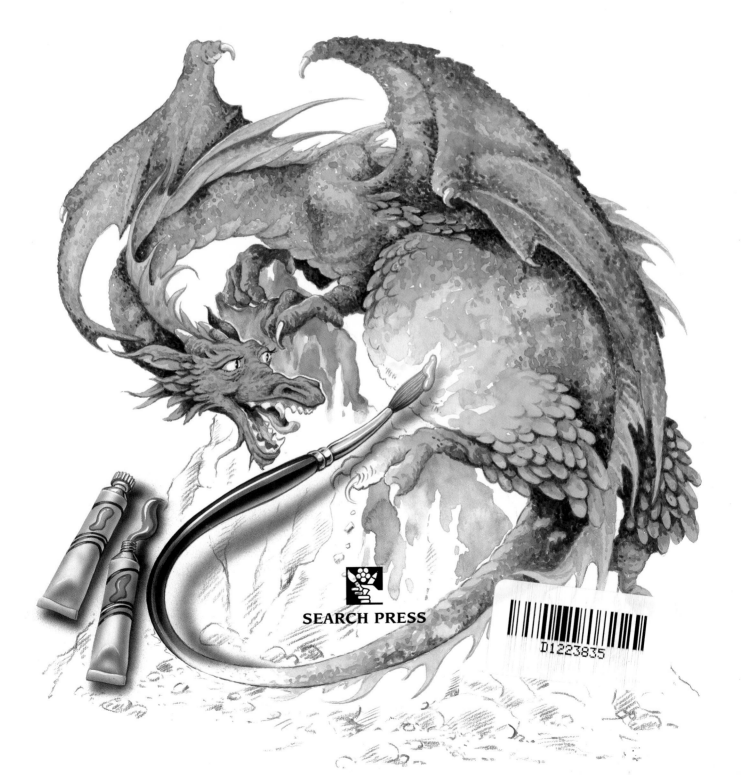

SEARCH PRESS

First published in paperback in Great Britain 2008

Search Press Limited
Wellwood, North Farm Road,
Tunbridge Wells, Kent TN2 3DR

First published in Hardback by Search Press Ltd 2007

Text copyright © Paul Bryn Davies 2006

Photographs by Steve Crispe, Search Press Studios

Photographs and design copyright © Search Press Ltd. 2006

ISBN: 978-1-84448-382-2

The Publishers and author can accept no responsibility for any consequences arising from the information, advice or instructions given in this publication.

The Publishers would like to thank Winsor & Newton for supplying some of the materials used in this book.

Suppliers
If you have difficulty in obtaining any of the materials or equipment mentioned in this book, then please visit the Search Press website for details of suppliers: www.searchpress.com

Publisher's note
All the step-by-step photographs in this book feature the author, Paul Bryn Davies, demonstrating his watercolour painting techniques. No models have been used.

There are references to animal hair brushes in this book. It is the Publisher's custom to recommend synthetic materials as substitutes for animal products wherever possible. There is now a large range of brushes available made from artificial fibres, and they are satisfactory substitutes for those made from natural fibres.

Acknowledgements

Thanks to Julie, my soulmate, for her constant encouragement.
Thanks also to Roz and Edd of Search Press for their enthusiasm for this project and commissioning the 'Mother' of all jobs.

Dedication

This book is dedicated to the memory of my brother, Peter Graham Davies.
'Ride On, Cowboy'

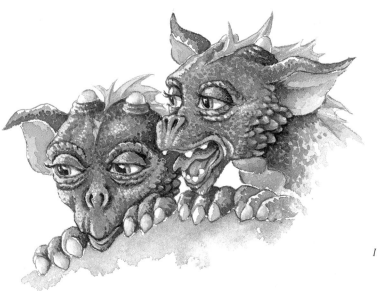

Printed in Malaysia by Times Offset (M) Sdn Bhd

Opposite:
Face-off
It is often rewarding to work with a limited palette of colours. Here warm colours are used: yellow ochre, burnt sienna, burnt umber, alizarin crimson; plus a little black and white. I like to inject an element of humour into my work – here I liked the idea that faced with this dilemma, a child would show no fear. The dragon featured here was inspired by studying the face of a crocodile.

Contents

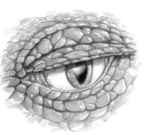

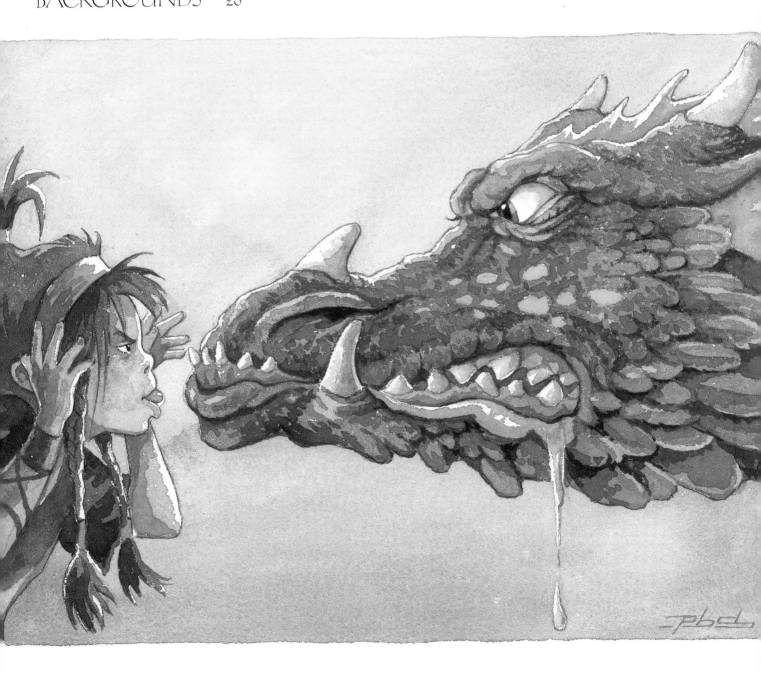

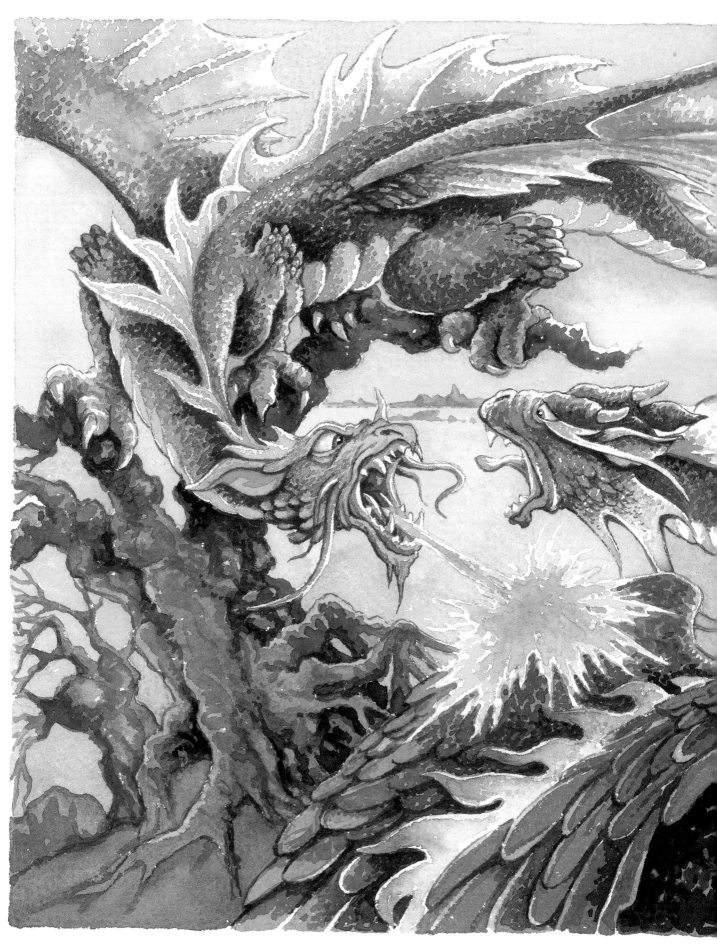

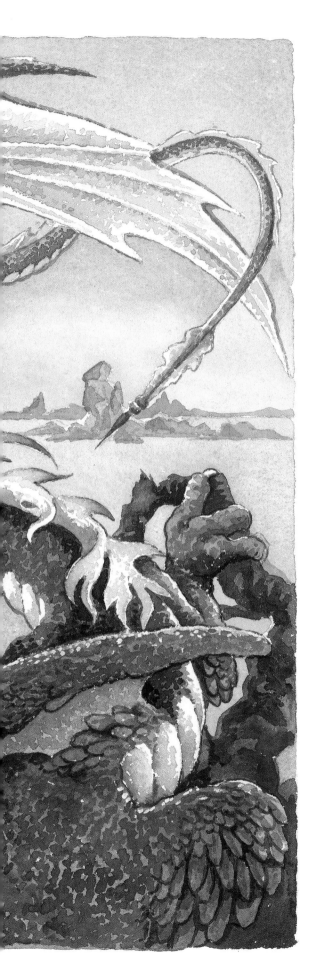

Introduction

The image of the dragon has fascinated artists, sculptors and film-makers for generations. Leonardo da Vinci, for example, was inspired by the fantastic. *Dragon Striking Down A Lion* (Uffizi Gallery, Florence) is a perfect example. Gustave Dore, another of my favourite artists, created superb dragons and serpents such as the great sea dragon featured in the *Destruction Of Leviathan* in his illustrated Bible of 1865.

Where do we begin to create the image of a great fire-breathing beast that exists only in mythology or in the minds of people like myself, who have rather overactive imaginations?

Dragons existed and still exist. The Tyrannosaurus Rex (the perfect wingless dragon) may be long extinct, but the iguana, the frilled lizard, the Komodo dragon of Indonesia and the bearded dragon of the Australian heartland are all perfect examples of living dragons. These reptiles may not fly or breathe fire, but using photographs of these and similar creatures is a great place to start your drawing. The faces and scale structures offer a perfect foundation on which to build your own creation. Alligators and crocodiles are also perfect for reference.

It is natural for anyone about to embark on a creative project where there is no immediate reference point to lack confidence, but there is no need to worry: the world is not going to end if you fail the first time or even the first dozen times!

Dragons can be created in any medium, but the focus of this book is to show the relative simplicity of using watercolour to create fantasy paintings. Whereas the landscape painter has a somewhat restricted palette (i.e. blue or grey skies, green trees and grass), the fantasy artist has none of these limitations. Skies can be red, yellow, or even green, limited only by the extent of your imagination.

Above all have fun with your painting. We are not here to slay dragons but to celebrate them. That said, should you happen to meet up with one, I would not recommend offering it a treat or stroking it – you may end up as toast!

Duel

A great deal of planning went into the design and composition at the drawing stage. Warm colours have been used for one dragon, cool colours for the other, to highlight the difference in the species. The background has been kept simple to keep the focus on the dragons themselves. Note how the tonal values of the background complement those of the creatures. The main techniques are wet-in-wet for the background, and wet-on-dry for the dragons.

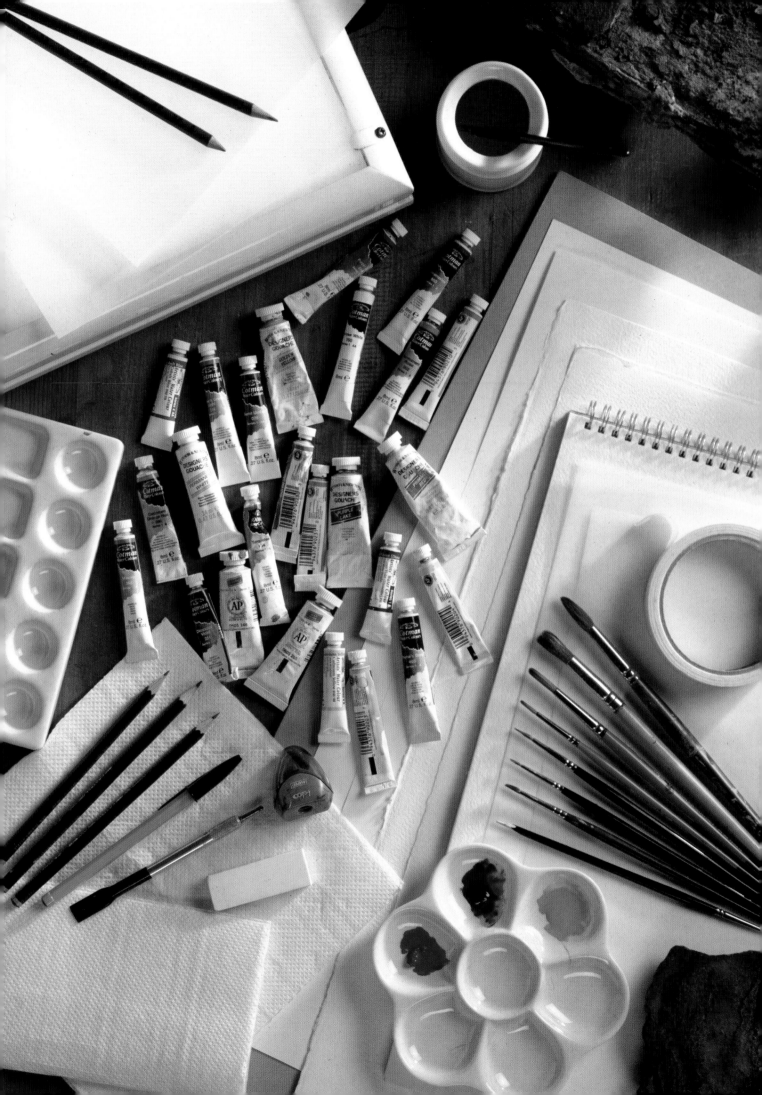

Materials

The quality of the materials you use largely depends on how much you are prepared to pay. In addition, the range of products available can be daunting, especially for the beginner. Hopefully I can offer you some simple guidance to choosing the right materials to begin your journey.

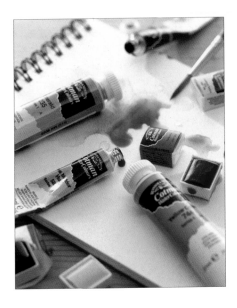

PAINTS

Watercolours are mainly available in two formats: pans and tubes; and two levels of quality: students' quality and artists' or professional quality. I would recommend tube paints, which can be purchased as a beginner's set, and I would suggest starting with around ten to twelve colours including the primaries.

If your budget can stretch to purchasing artists' quality colours, all the better, as these offer richer pigments. I tend to use a combination of both students' and artists' quality colours; and many of the paintings in this book were painted using only students' quality colours.

You should also add some white gouache to your collection. Watercolour has a translucent quality whereas gouache offers a great deal of opacity, which makes it ideal for highlighting.

BRUSHES

This area can also be somewhat of a minefield with such a wide range of choices. Brushes are available as pure sable, a sable/synthetic mix and plain synthetic (the cheapest).

Pure sable brushes are the best quality choice, but are expensive. Some of these are handmade and individually tested by the manufacturer, so you can imagine the cost! This quality of brush will give you the perfect combination of carrying a useful amount of paint and ease of control; and they will also keep a fine point.

As a compromise, I would recommend using sable mix brushes, as these will be more than adequate. Use sizes 00, 1, 2 and 3 for areas of detail, and sizes 5, 6 and 7 for the broader colour washes used for the skies and the basic backgrounds. Synthetic brushes are adequate for larger wash areas.

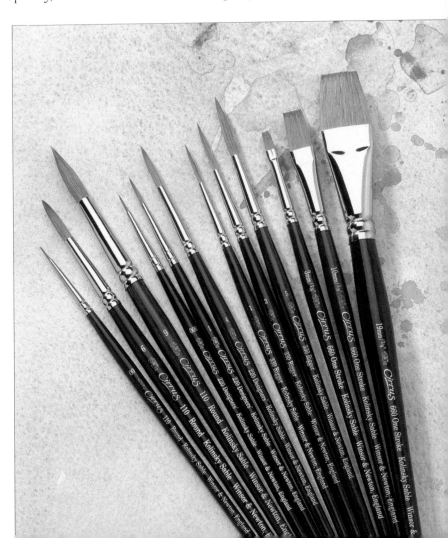

PAPER

This is not an area in which to cut corners. Watercolour paper is available in various finishes from smooth to rough and various weights (thicknesses). Cockling or buckling of the paper can be avoided by using a heavier grade paper when applying larger areas of colour wash. The heaviest paper is 300lb (640gsm) and is more like card than paper. The ideal weight of paper I would recommend when getting started would be 140lb (300gsm).

The finishes or surface textures of watercolour paper are HP, which stands for hot pressed, and is very smooth; NOT or cold pressed (semi-rough); and rough, which is heavily textured. The majority of the paintings in this book are produced using 140lb (300gsm) NOT finish paper, with the exception of *Dragon's Tale* (pages 30–31) which was painted on HP paper.

BOARD

Again, this is an area where you can spend a lot of money or very little depending on your budget. The top of your working surface needs to be smooth and stable, so for the projects covered in this book I feel a drawing board would be most suitable. An easel is more often used for looser, sketchy subjects and would probably lack the stability you need for the detail work, but is a good alternative to a drawing board.

Purpose-made drawing boards are ideal but can be expensive as they often come complete with a parallel motion mechanism for squaring up your work – useful, but certainly not necessary in the early stages of the learning process.

A more practical option is to purchase a piece of MDF (medium density fibreboard) measuring around 650 x 480mm (25½ x 19in). You could also use a piece of melamine (plastic) faced chipboard as an alternative to the above. Both of these items are relatively inexpensive and when used on a tabletop are perfectly adequate for the job.

OTHER ITEMS

Pencils and pencil sharpener
Everything starts with the pencil. You will need several grades: a harder point (H) medium-hard (HB) and soft (B). These three grades should be ideal for starting your composition. Keep a good point on your pencils by using the pencil sharpener.

Eraser
Use a soft putty eraser or similar (a harder one can damage your work) in the unlikely event you make a mistake!

Kitchen towel
This can be used for wiping off excess paint from your brushes and mopping up spillages.

Masking tape
Used to secure your paper to the drawing surface or board.

Tracing paper or pad
Available in sheet or pad formats, this is used for transferring your rough layouts to the watercolour paper surface.

Burnisher
Simply rub the burnisher over the back of a tracing to transfer it to a new piece of paper. These can be purchased as purpose made tools or you can use a ballpoint pen cap, brush handle or similar item.

Layout pad/sketch pad or printer paper
For creating your first drafts and planning your compositions.

Hairdryer
A hairdryer can be used to speed up the drying process, and helps to prevent the paper cockling.

Light box
This is a luxury, but if you are in the fortunate position to be able to afford one, you can save a fair amount of time when tracing. The light box can save time as your rough drawing can be traced in reverse, thus eliminating the need to go over the tracing twice.

Palette
Try to use the traditional china palettes as these are stable and make colour mixing easier. A cheaper alternative would be a plastic palette.

Water pot
The ideal container is a plastic, spill-proof pot. This is inexpensive and can help to avoid accidents. If this is not available, the good old jam jar is a great alternative!

DRAGON LORE TIP
You can use a paint brush as a burnishing tool. Carefully remove the paint at the end of the handle with a craft knife to prevent marking the tracing paper when burnishing.

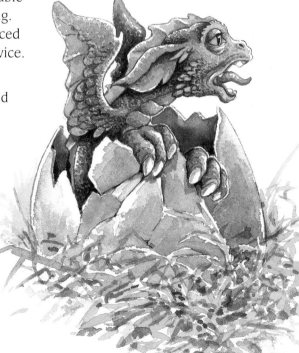

First Breath

The baby dragon here is breaking free from its egg. The colours here are Indian red mixed with burnt sienna for the main body, and raw sienna for the details. The darker areas were produced by adding dioxazine violet to these colours.

The eggshell was painted with a wash of Payne's grey overlaid with a watery mix of permanent mauve.

9

Techniques

The following pages show some ideas which will help you to bring your illustrated dragon to life. Once your composition is created, these textures and effects help to model the dragon and give it a three-dimensional feel.

WET-IN-WET

Here the technique is wet-in-wet to simulate the look of a projected fireball or fire exploding on impact. This can be seen in *Duel* on pages 4–5. The fire can be any shape you wish but as shown here it has a great sense of speed and power.

 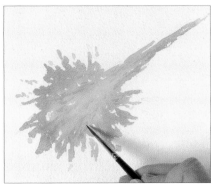

1 Very loosely, paint in a thin wash of gamboge yellow. Push the paint around to ensure you do not end up with a flat colour.

2 Drop in cadmium red wet-in-wet, keeping to the outer edges of the fireball. Dry with a hairdryer.

3 Add mauve to cadmium red and draw loose, broken lines on the fireball. Remember that the lines should follow the direction of the flame.

STIPPLING

A very simple technique using stippling to simulate a leathery, uneven look to the bulk body area of your dragon. This is very useful for small scales.

1 Lay in a thin wash of Hooker's green. Dry with a hairdryer.

2 Make a stronger mix, and stipple dots of this on to the dried wash by dotting the brush quickly on to the area. Allow some to merge into one another, but keep the overall density as even as you can.

HIGHLIGHTING AND SHADING

Larger scales are drawn individually rather than stippled like the smaller-scaled areas. Used on certain areas of the body (i.e. the wings, shoulders and back of the legs.), these larger scales give more form and interest to the overall skin texture. The less uniform the skin texture, the more character your dragon will have.

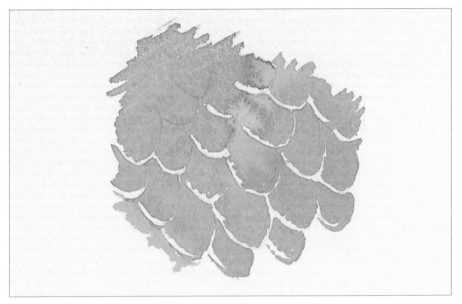

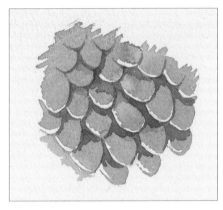

1 Sketch out the scales using a mix of burnt sienna and cadmium red deep. Paint each one with a wash, leaving a white section at one edge for a highlight. Do not keep the borders too neat: a rough edge suggests texture.

2 Deepen the mix by adding a little dioxazine violet, and paint in the shading at the base of each scale using a size 3 brush.

3 Deepen the shades in the furthest recesses by adding a little more dioxazine violet to the mix. Use permanent white gouache to paint in the final highlights. You can also use this to introduce highlights if you missed any earlier.

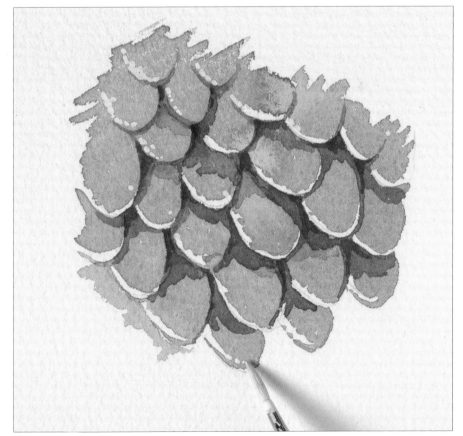

Dragon colours

The choice of colours for your dragon is a matter for your own taste. Largely the only rules are do not overdo the range of colours and choose one colour that complements the other. I would suggest limiting the colours to a deeper colour for the body mass with a paler, secondary colour for the crest, belly and under the wings. Below you will find some examples.

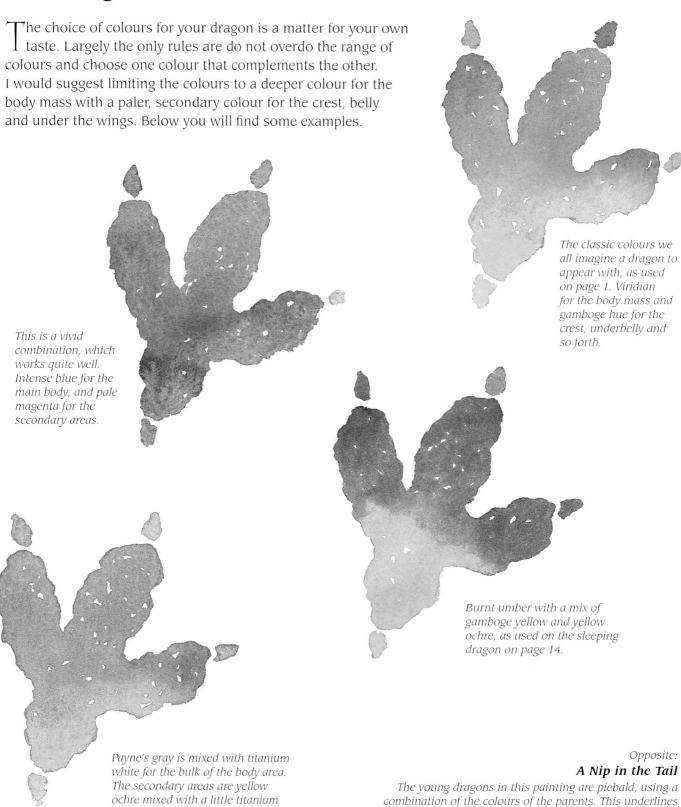

The classic colours we all imagine a dragon to appear with, as used on page 1. Viridian for the body mass and gamboge hue for the crest, underbelly and so forth.

This is a vivid combination, which works quite well. Intense blue for the main body, and pale magenta for the secondary areas.

Burnt umber with a mix of gamboge yellow and yellow ochre, as used on the sleeping dragon on page 14.

Payne's gray is mixed with titanium white for the bulk of the body area. The secondary areas are yellow ochre mixed with a little titanium white. This combination is used on the male opposite.

Opposite:
A Nip in the Tail

The young dragons in this painting are piebald, using a combination of the colours of the parents. This underlines the idea that this is a family unit and the colours used are a stark contrast against the darkness of the cave. Notice how the rock formations are paler towards the light source, in this case the cave entrance.

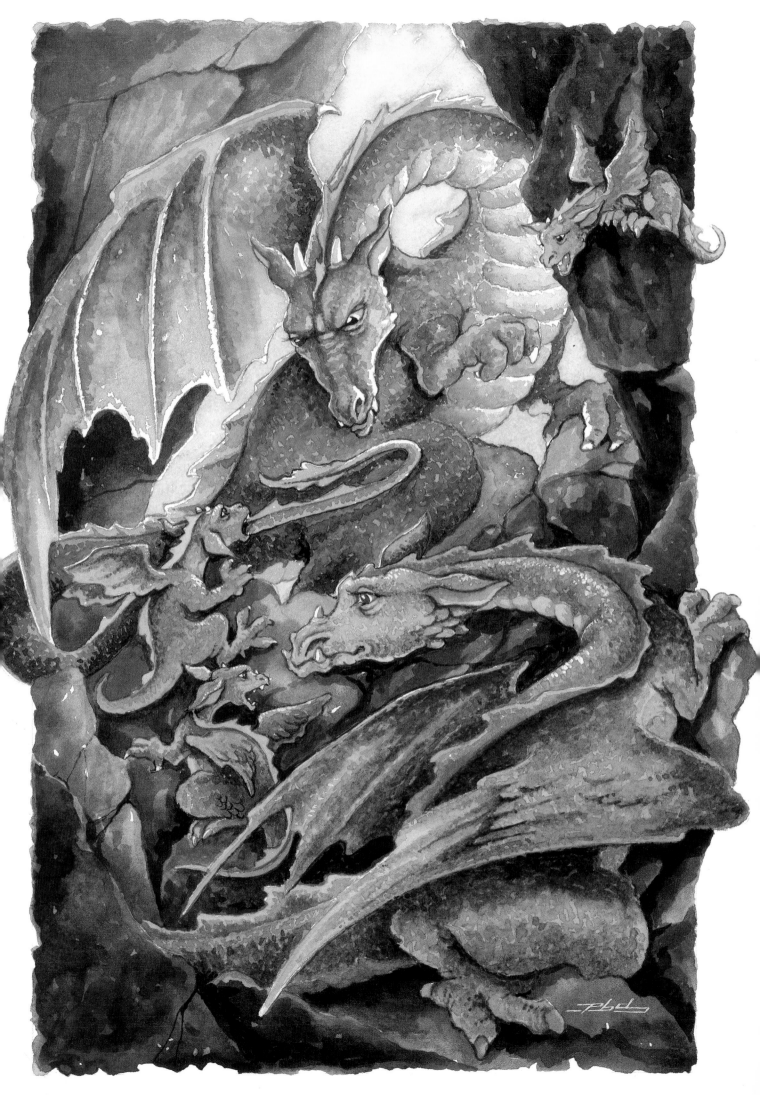

Drawing dragons

As mentioned in the introduction, it can be very useful to study photographic reference of living animals. I find it helpful to break the structure down into simple shapes such as ellipses, circles and triangles to help create your basic drawing. To help with this, try placing a sheet of tracing paper over the photograph and sketching these simple shapes over the top.

SLEEPING

I have absolutely no idea what position a dragon may take whilst sleeping, so the answer was to copy the position a dog might take up in front of a fire or curled up at the bottom of the bed!

1 Sketch in simple triangular and oval shapes with an HB pencil to suggest the shape and position of the dragon.

2 Use an HB pencil to tighten up the shapes and add scales, toes and so on to detail the dragon.

3 Go over this with a ballpoint pen to darken the picture. Add the background and final details.

4 Lay a sheet of tracing paper over the picture and trace the dragon with an H pencil. Flip the tracing paper over and go over the lines using a B pencil.

5 Flip the tracing back over and lay it on your watercolour paper. Use a burnishing tool to transfer the picture.

6 Remove the tracing paper and reinforce the outline with a size 1 sable brush and burnt umber. The dragon is now ready for paint!

The dragon here is shown how it may sleep in the open air – possibly after a heavy lunch. A snoozing dog was the inspiration: notice how the face resembles a dog's.

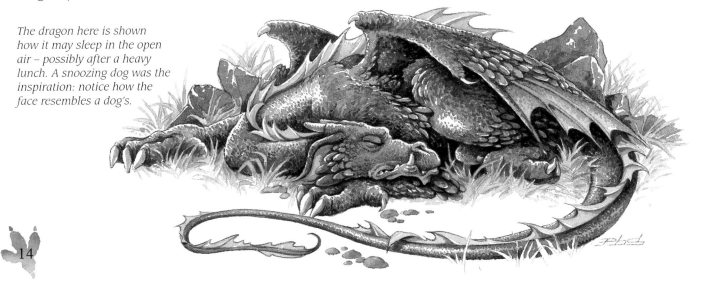

PERCHED

The answer to keeping a sense of balance to your perched dragon is to keep the weight and power in the back legs. Again, there are certain elements of real animals here.

1 Draw the basic shapes with an HB pencil. Notice how the wings, crest and ears are almost triangular, while the tail and neck are sinuous.

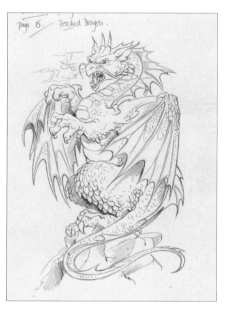

2 Fill in the details with a ballpoint pen. Notice the smoke curling from his nostrils.

3 Trace the dragon with an H pencil, flip the paper and trace again with a B pencil.

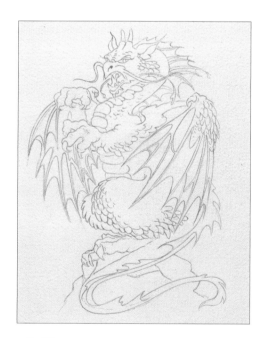

4 Flip the tracing paper and transfer the picture to the watercolour paper with the burnishing tool. Reinforce the outline with a size 1 sable brush and sap green. Use Davy's gray for the mouth and crest.

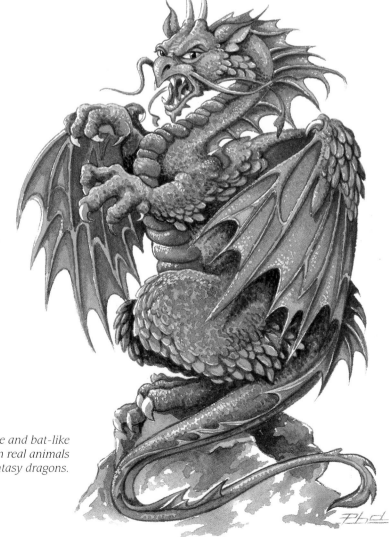

This dragon has a hawk-like face and bat-like wings, showing how elements from real animals can add realism to your fantasy dragons.

STANDING

The front legs of your dragon, traditionally, should be shorter than the hind legs. Therefore, to produce a realistic stance, the hind legs need to have at least two joints. Have a look at the hind legs of iguanas or other reptiles for help.

1 Sketch in the basic shapes with an HB pencil. This aggressive young male is made up of more angular shapes than the previous examples. This gives a beefy, powerful aspect to the dragon.

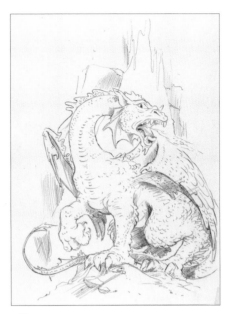

2 Add detail with a ballpoint pen, adding the background and major shaded areas.

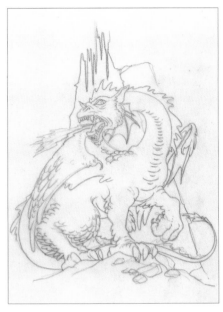

3 Trace the picture with an H pencil, then flip it over and go over the lines with a B pencil.

4 Place the tracing paper over the watercolour paper and transfer the picture using the burnishing tool. Reinforce the lines with Davy's gray and a size 1 sable brush.

This dragon's pose suggests weight and strength – perfect for guarding his hoard!

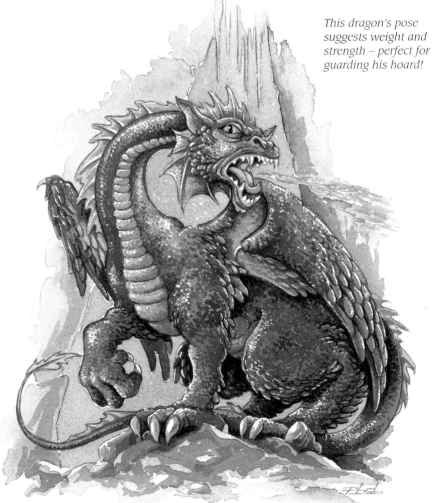

FLYING

The body of a flying dragon here was inspired by a leaping big cat. The head and neck are stretched downward to emphasise the height at which the dragon is flying.

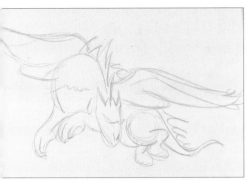

1 Sketch the basic shapes with an HB pencil. Use curves and sweeping lines to suggest grace and weightlessness.

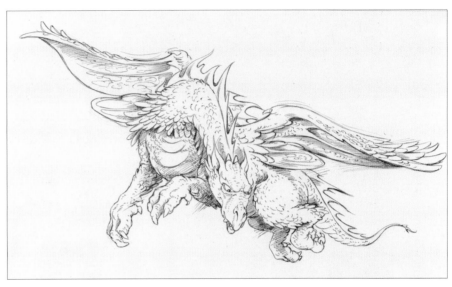

2 As with the other demonstrations, add detail to the dragon with a ballpoint pen.

3 Trace the picture with an H pencil, flip the tracing and go over the lines with a B pencil.

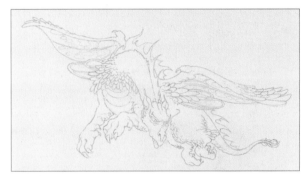

4 Lay the tracing onto watercolour paper and transfer the pencil using a burnishing tool. Reinforce the lines with Indian red and French ultramarine as shown, using a size 1 sable brush.

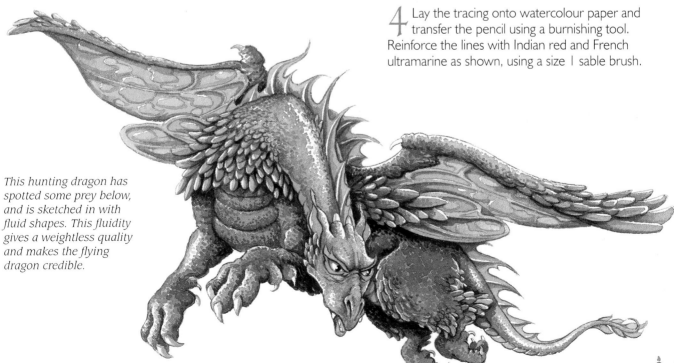

This hunting dragon has spotted some prey below, and is sketched in with fluid shapes. This fluidity gives a weightless quality and makes the flying dragon credible.

FACES

This is probably the trickiest part of creation for the beginner – and often for the professional artist too! Tricky, but very important, as this will define the character of your dragon.

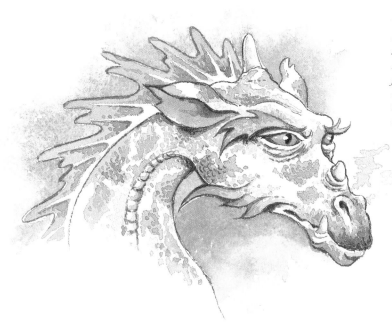

The passive, almost thoughtful expression of this piebald suggests this is a female, as do the slender and delicate features. The main colour is yellow ochre, with a little permanent mauve for the details. Shadow areas on the white of the paper are a mix of Payne's grey and French ultramarine. French ultramarine was also used for the background, to help enhance the white areas.

This face is aggressive and threatening. Definitely a young male! To achieve this expression, shorten the length of the snout, flare the nostrils and emphasise the mouth to create a gaping effect. Notice how the eyes are narrowed and the eyebrow areas are pulled down towards the nose. The colours are Davy's grey mixed with dioxazine violet; and alizarin crimson mixed with Chinese white.

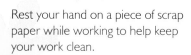

DRAGON LORE TIP

Rest your hand on a piece of scrap paper while working to help keep your work clean.

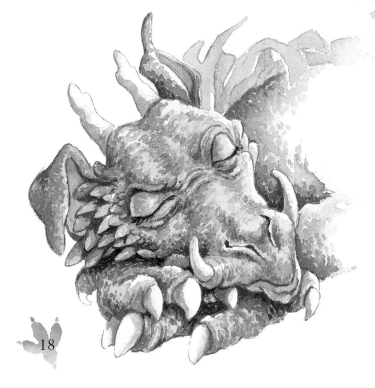

This male appears harmless, taking on the pose of a sleeping puppy or cat. Note the tusks by way of change from the usual fangs. The colours are Indian red with dioxazine violet for the main body; and yellow ochre with permanent mauve for the crest.

The emphasis on this picture of grooming dragons is on gentleness and passivity; and is similar to the way horses bond by grooming, creating companionship.

The larger head on the green dragon suggests this is the male, and he was painted with Hooker's green light with Prussian blue added for the darker areas. Gamboge yellow was used for the details, with dioxazine violet added for the darker tones. The female was painted with a mix of raw sienna with burnt umber, and dioxazine violet for the darker areas.

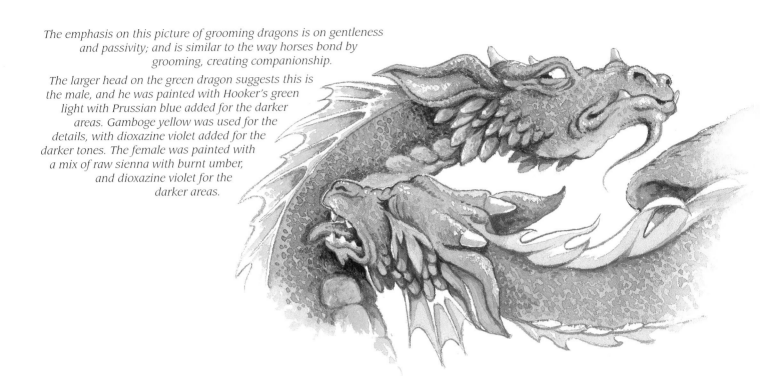

A pair of twins around six months old. Their faces have been made rounder and broader, and the eyes and ears larger, which gives the animals a more juvenile look.

Note also the 'stubby' horns, teeth and claws, and the shorter snouts, both effects that help to underline their immaturity. Small, under-developed wings can also denote immaturity (see page 9 for another example of a young dragon).

The colours used were Davy's gray mixed with French ultramarine and dioxazine violet; raw sienna for the crests; and alizarin crimson and Chinese white for the ears and mouth.

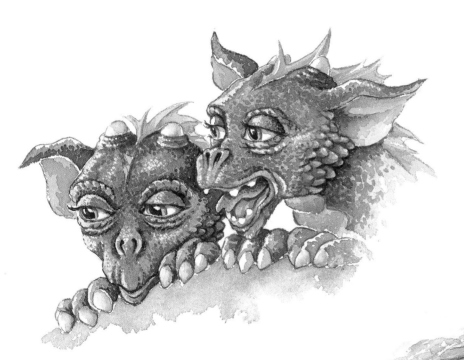

This close-up of a dragon's eye shows the reptilian scales. Here the eyes of the lizard, the scales of a snake, and a little imagination were used as reference points. The colours used here are Hooker's green light with viridian mixed with French ultramarine for the deeper recesses. The iris was painted with a yellow ochre and alizarin crimson mix, and titanium white for the details.

WINGS

As with other parts of the dragon, ideas for constructing the wings can be found by referring to living creatures such as bats, birds and insects.

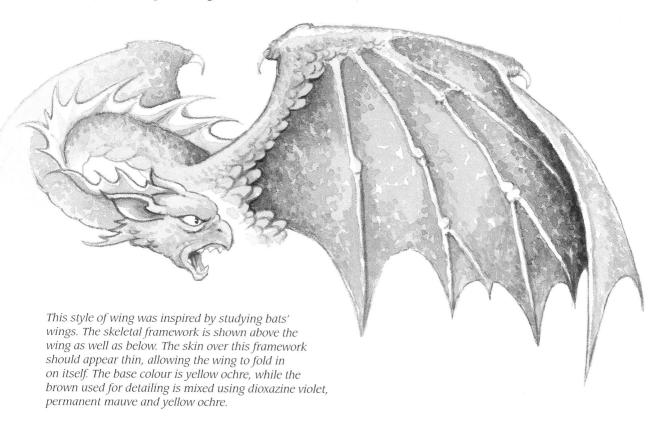

This style of wing was inspired by studying bats' wings. The skeletal framework is shown above the wing as well as below. The skin over this framework should appear thin, allowing the wing to fold in on itself. The base colour is yellow ochre, while the brown used for detailing is mixed using dioxazine violet, permanent mauve and yellow ochre.

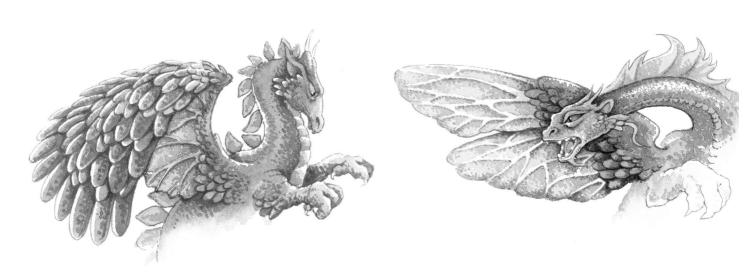

Here the scales of the wing are used to emulate the feathers of a bird's wing. The scales are layered and increase in length towards the end of the wing. Another example of the 'feather-scaled' wing can be seen in Duel *on pages 4–5. Mix Davy's gray and French ultramarine for the main colour, and paint the details with a yellow ochre and permanent mauve mix.*

This wing form was created after looking at reference to the way the wings of wasps and other flying insects are constructed. The colours used are Hooker's green plus Prussian blue for darker areas. The crest and wings are a mix of gamboge yellow and Hooker's green light.

LEGS AND FEET

The style of your dragon's legs and feet is largely a matter of personal choice, but as a general rule it is preferable that the front legs are somewhat shorter than the hind legs. Here are some styles to help get you started.

This view shows the softer 'palm' area of the foreleg. Payne's gray with dioxazine violet was used for the scales, and cadmium red deep was mixed with burnt sienna for the palm.

This dragon's forelegs have two joints, and toes and claws that are designed to grip. Indian red is the dominant colour, with dioxazine violet for the darker areas, and raw sienna for the crest and underbelly.

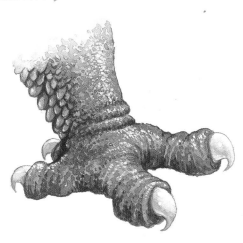

This hind leg shows the extra joints and should be drawn to look longer and heavier than the forelegs to denote a feeling of power. The colours are Davy's gray mixed with Prussian blue, with some ivory black added for the darker areas.

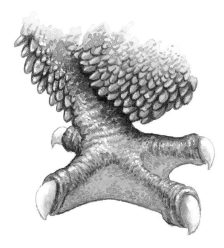

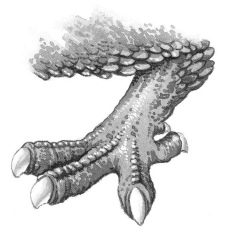

The webbed foot here suggest this is a sea dragon. Using reference of birds with webbed feet (seagulls, ducks and waders) can help with this style. Use a mix of viridian and gamboge yellow for the green, with Prussian blue and ivory black for the darker areas. Highlights were added with permanent white gouache.

This narrower leg style has a slightly bird-like feel to it. Note the additional small claw at the back of the foot. The leg was painted with Payne's gray with dioxazine violet and Chinese white. Again, permanent white gouache is used for the highlights.

This thicker-set leg has two toes to the front and two to the back. The sharper claws are more like talons – possibly for the dragon to snatch prey from the ground whilst in flight. The colours used are burnt sienna and burnt umber for the details and Payne's gray for the claws.

TAILS

The purpose of a dragon's tail is two-fold: it is both a balancing tool or rudder for flight and also a weapon; usually used when two males are fighting over territory or the favours of a female. Try to keep the tail of your painted dragon in proportion to the body and show a good sense of flexibility.

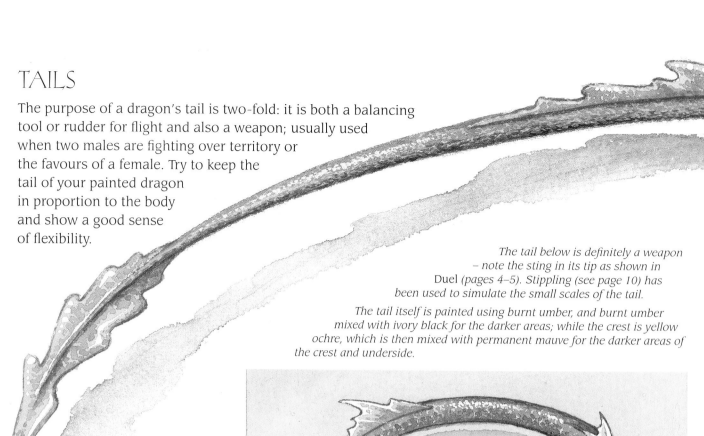

The tail below is definitely a weapon – note the sting in its tip as shown in Duel *(pages 4–5). Stippling (see page 10) has been used to simulate the small scales of the tail.*

The tail itself is painted using burnt umber, and burnt umber mixed with ivory black for the darker areas; while the crest is yellow ochre, which is then mixed with permanent mauve for the darker areas of the crest and underside.

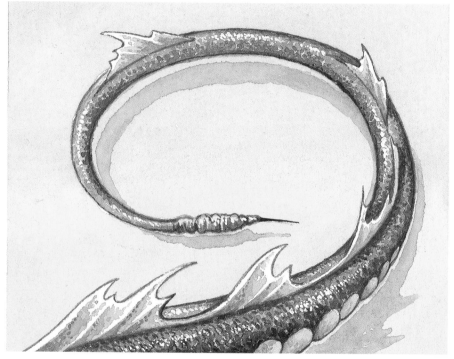

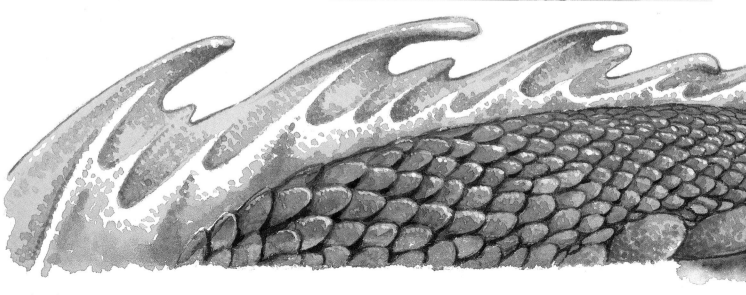

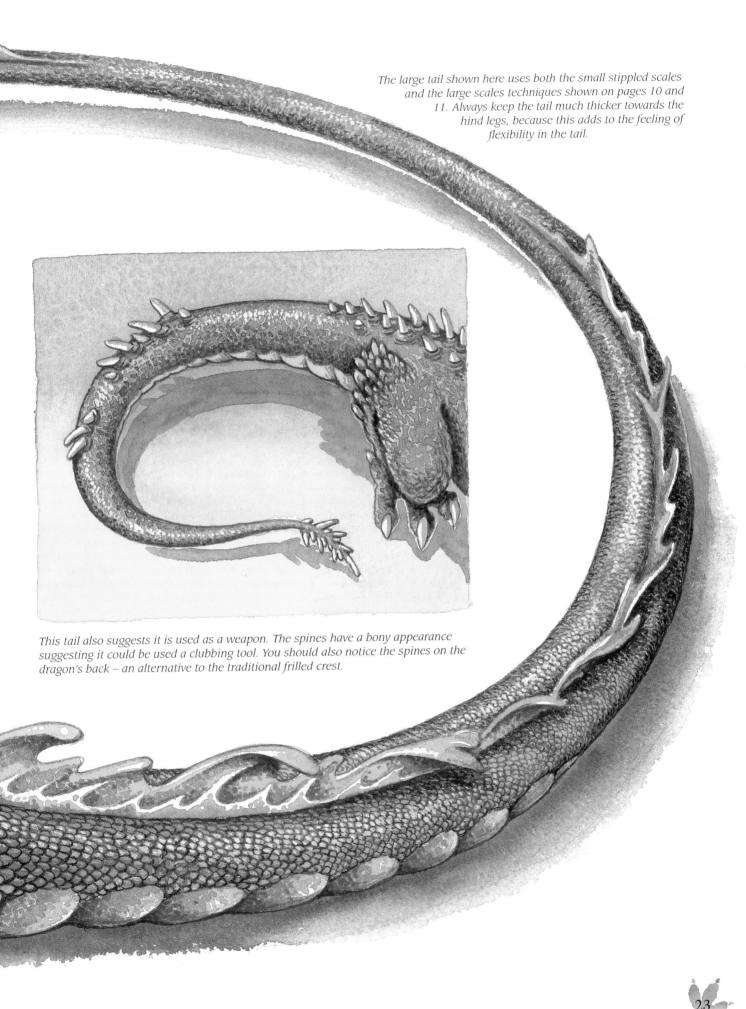

The large tail shown here uses both the small stippled scales and the large scales techniques shown on pages 10 and 11. Always keep the tail much thicker towards the hind legs, because this adds to the feeling of flexibility in the tail.

This tail also suggests it is used as a weapon. The spines have a bony appearance suggesting it could be used a clubbing tool. You should also notice the spines on the dragon's back – an alternative to the traditional frilled crest.

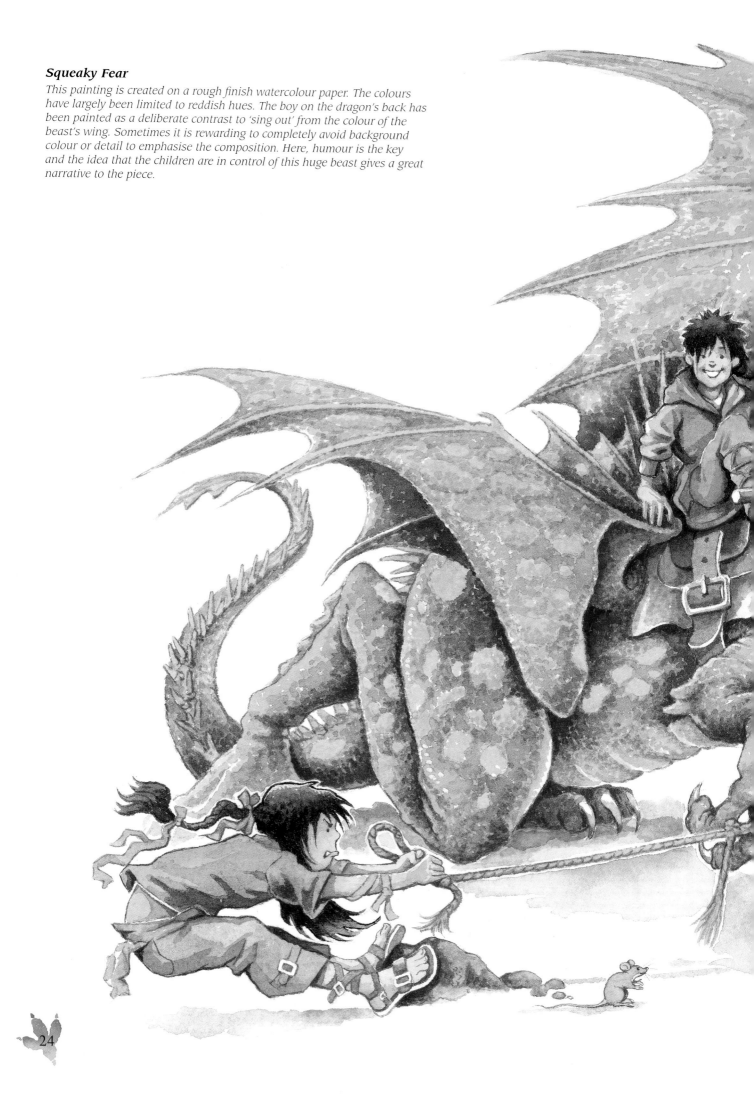

Squeaky Fear

This painting is created on a rough finish watercolour paper. The colours have largely been limited to reddish hues. The boy on the dragon's back has been painted as a deliberate contrast to 'sing out' from the colour of the beast's wing. Sometimes it is rewarding to completely avoid background colour or detail to emphasise the composition. Here, humour is the key and the idea that the children are in control of this huge beast gives a great narrative to the piece.

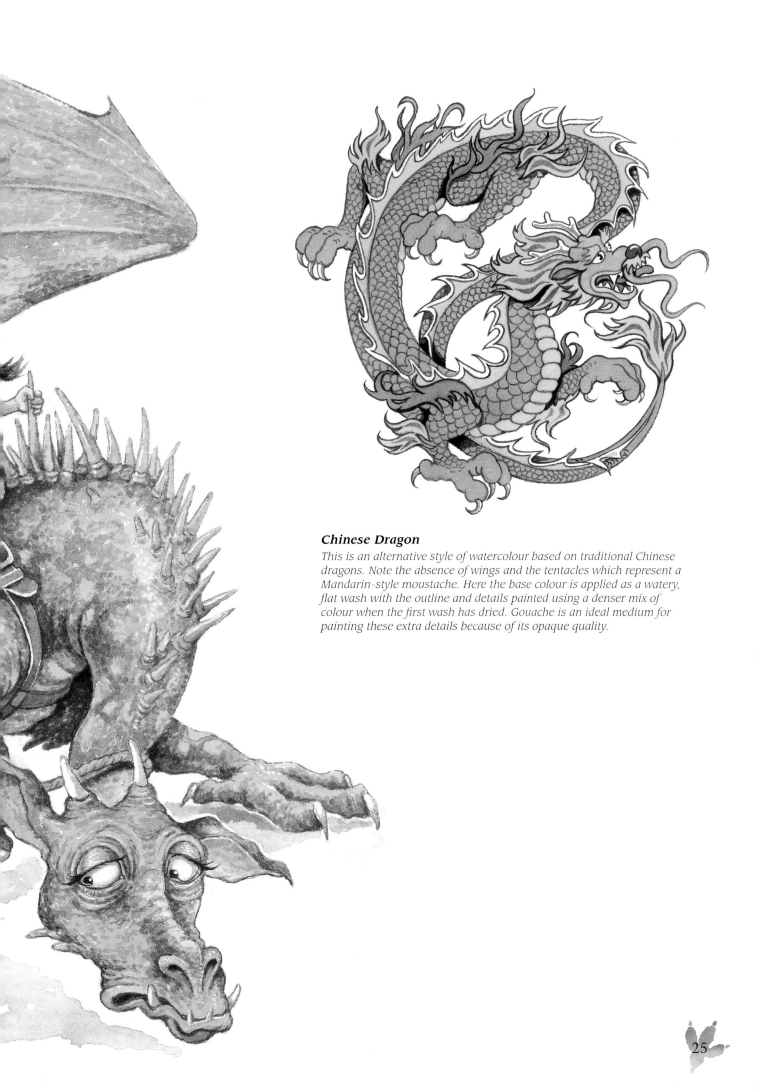

Chinese Dragon

This is an alternative style of watercolour based on traditional Chinese dragons. Note the absence of wings and the tentacles which represent a Mandarin-style moustache. Here the base colour is applied as a watery, flat wash with the outline and details painted using a denser mix of colour when the first wash has dried. Gouache is an ideal medium for painting these extra details because of its opaque quality.

Backgrounds

It can be beneficial to keep the backgrounds simple so as not to detract from the chief element of the composition – the dragon. Use a looser style and keep the detail restricted to the dragon and the immediate foreground. Mountains and landscapes can take on a lunar feel with valleys and rock formations as bizarre as you like. Using photographic reference to fantastic scenic landforms such as North America's Grand Canyon and Bryce Canyon National Park, where millions of years of erosion have created amazing rock formations, can help you to create the perfect backdrop to your dragon painting. For trees and bizarre vegetation use reference photographs of rainforests or even the swamplands of America's deep south. Volcanoes and lava fields can also be included in your backgrounds.

SKIES

Skies can be painted in virtually any colour in a fantasy landscape. Here I have used a green sky.

YOU WILL NEED

Watercolour paper, 140lb (300gsm) NOT finish
HB pencil
Hairdryer
Size 3 round brush
Paints:

Intense green, gamboge yellow, intense blue, alizarin crimson, Prussian blue, rose madder, burnt sienna, dioxazine violet, burnt umber, permanent mauve, raw sienna, sap green, yellow ochre, ivory black, purple madder, Davy's gray and French ultramarine

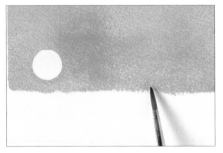

1 Use a size 3 brush to lay in a thin flat wash of intense green from top to bottom, watering it down as you get closer to the bottom. Leave a space for the sun as shown.

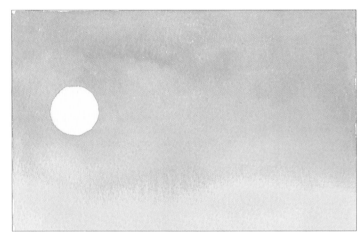

2 Lay in a thin wash of gamboge yellow, blending it into the green. Again, water it down as you get near the bottom, and allow the paint to dry completely before continuing.

3 Paint in the sun using gamboge yellow, and dry it with the hairdryer. Add a touch of intense blue to the green wash and use this to draw some clouds across the painting.

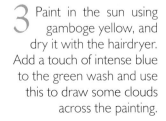

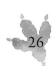

MOUNTAINS

Here warm colours are used to create the mood and feel of an evening sky. The colours used in the mountains should complement those of the sky and sea.

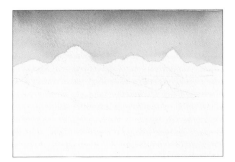

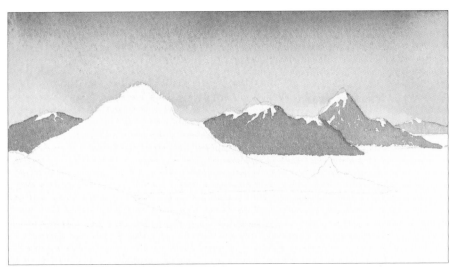

1 Sketch out the basic shapes, and paint in the sky with the size 3 brush, fading from alizarin crimson to gamboge yellow, following the instructions for painting skies opposite.

2 Paint in the distant mountains with a mix of Prussian blue and rose madder, leaving white paper showing through to represent snow at the tops. Soften the mountains at the bottom by adding a little water on to the paper.

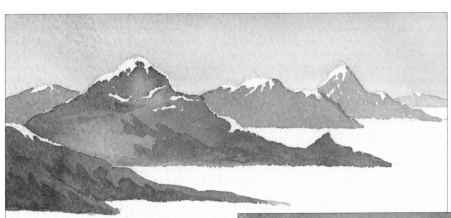

3 Paint in the mid-distance mountain with a stronger mix of the same colours, and add burnt sienna wet-in-wet at the bottom. Intensify the colours still more by adding more paint to the mixes and add some wet-on-dry details to the closest mountains.

DRAGON LORE TIP

Try to use colours that complement one another. If you're not sure how colours will look together, experiment on a spare piece of scrap paper before using your more expensive watercolour paper.

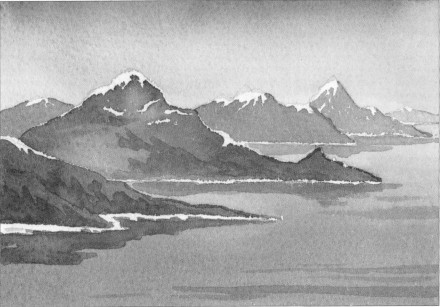

4 Paint in the sea as a reflection of the sky, adding dioxazine violet at the bottom wet-in-wet. Use the mountains mix to add reflections.

FOREST

When painting trees or forests, try to keep a sense of the bizarre in your drawing as this will add an extra element of fantasy to your composition. Old dead trees and exposed rock formations can be useful for reference.

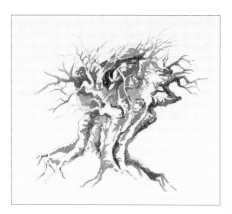

1 Using the size 3 brush, mix burnt umber with dioxazine violet and paint in the dark shades. Vary the strength of the mix and the ratio of the paints to each other to ensure that the tree does not look flat.

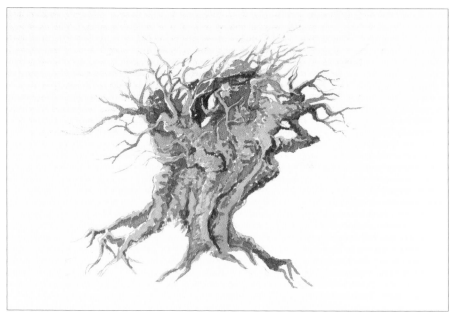

2 Add raw sienna and permanent mauve into the white areas, but keep some intact patches of white showing through.

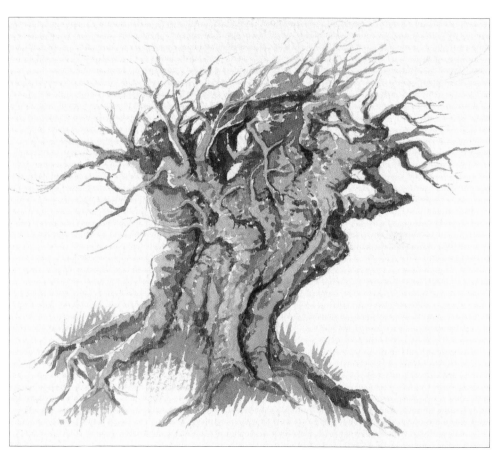

3 Mix sap green and Prussian blue with a touch of yellow ochre. With short downward strokes, paint grass in and around the roots of the tree. Soften ivory black with purple madder and paint the deepest recesses with a strong mix.

28

ROCKY OUTCROPS

Rock formations are always useful to include in your backdrops. Look in your old geography books for reference. The formation shown here is loosely based on those found in national parks around the world.

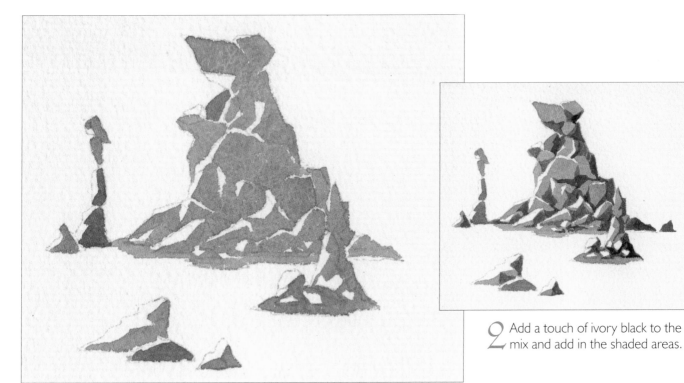

2 Add a touch of ivory black to the mix and add in the shaded areas.

1 Paint a mix of Davy's gray and French ultramarine on to the rocks, being careful to keep within the lines, and leaving a few sharp white highlights.

3 Make a fairly thin mix of French ultramarine with Davy's gray and paint in the sea. Dry with the hairdryer and add a touch of ivory black to the mix. Add reflections with this darker mix wet-on-dry, then add final deep shadows with a mix of Davy's gray, French ultramarine and ivory black.

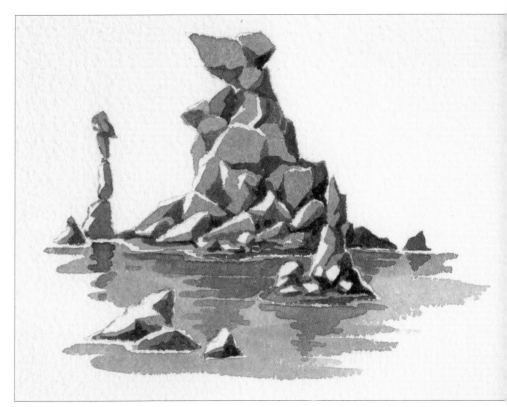

Dragon's Tale

Here I liked the idea of a role reversal: a child reading a bedtime story to a dragon.

This painting highlights the importance of creating light and shade in your compositions. Although the picture is created entirely in watercolour and gouache, the advanced techniques used here are beyond the scope of the book.

The painting uses the same techniques as for traditional watercolours, but the application of the paint is very different. The basic colour here was applied using an airbrush (a kind of miniature spray gun), and the detail work was then added using similar techniques to those in this book. When these were painted over the base colour, another layer of paint was oversprayed to build up the depth of colour. The translucent qualities of watercolour allow the details underneath to show through.

Note how the mouth of the cave is the source of light. The special effects for the rays of light were created with the airbrush using a thin, watery mix of permanent white gouache.

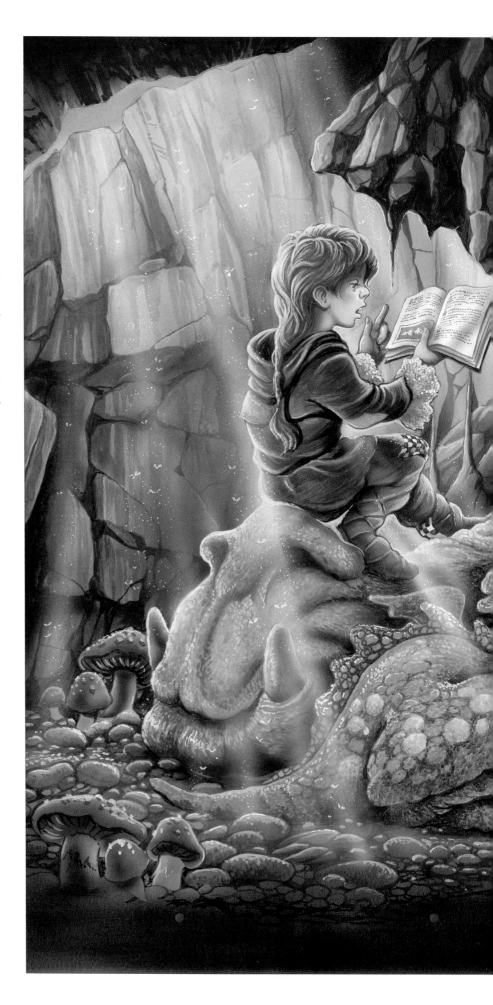

30

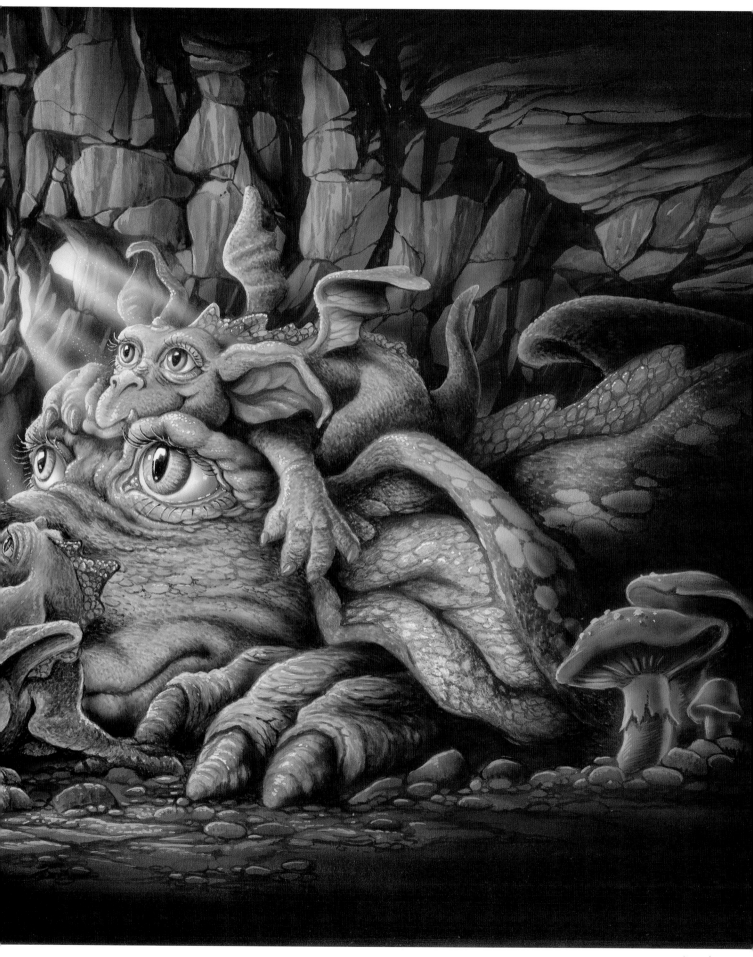

Caring Wing

The idea behind this painting was to illustrate the relationship between father and son. This composition is largely a design exercise with the emphasis on creating a fairly decorative piece.

The young dragon has his legs crossed to emulate his father's stance. The background is kept deliberately basic so as not to distract from the main composition. Note how the mountains break into the circle created by the sun.

YOU WILL NEED

Watercolour paper, 140lb (300gsm) NOT finish

Tracing paper

Printer paper

Hairdryer

HB, B and H pencils

Ballpoint pen

Burnishing tool

Paintbrushes:

Size 1 sable, size 2 sable, size 3 round and size 6 round

Paints:

Davy's gray, burnt umber, intense blue, dioxazine violet, permanent mauve, cadmium red, cadmium orange, raw sienna, gamboge yellow, French ultramarine, alizarin crimson, burnt umber, cobalt violet, ivory black, Chinese white, and white gouache

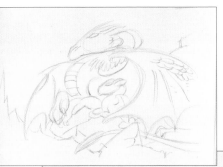

1 Use an HB pencil to sketch in the basic shape of the composition. Note how the wings sweep protectively around the younger dragon, creating an arch surmounted by the watchful eyes of the adult. The overall shape is an oval, with the young dragon as the focal point.

2 Detail the picture with the HB pencil. Once you are happy with it, go over the lines with the ballpoint pen.

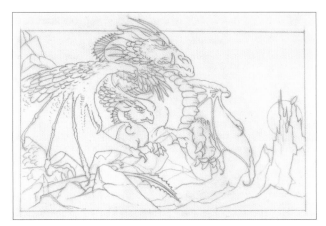

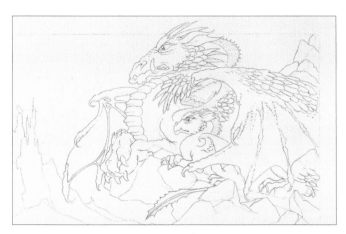

3 Lay a sheet of tracing paper over the picture and trace the lines through using the H pencil. Flip the tracing paper and use the B pencil to trace once more.

4 Transfer the picture to the watercolour paper using the burnishing tool, and then reinforce the outline using the size 1 sable brush with Davy's gray for the dragons, and burnt umber for the background rocks.

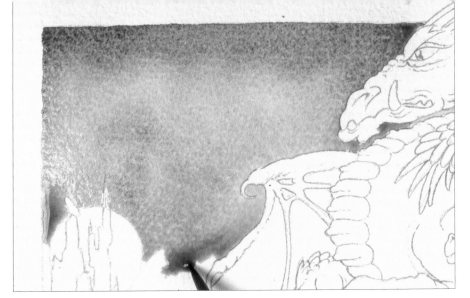

5 Using the size 6 round and a thin mix of intense blue, dioxazine violet and a touch of permanent mauve, wash in the sky from top to bottom, being careful to stay out of the pencil lines. Add more dioxazine violet and water as you near the bottom to fade the sky. Work more permanent mauve into the mix as shown.

6 Mix a wash of cadmium red and cadmium orange, and feed this into the permanent mauve.

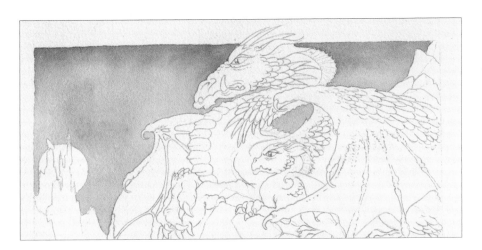

7 Working wet-in-wet, add gamboge yellow below the orange area. Complete the sky, including areas framed by the dragons' bodies, and dry with the hairdryer. Notice how the colours get less intense as they dry.

8 With a Davy's gray and French ultramarine mix, use the size 3 sable brush to paint the main areas of the dragons' skin. Place the paint and push it around the shape, leaving bare paper at the top left edges of areas for highlights as shown.

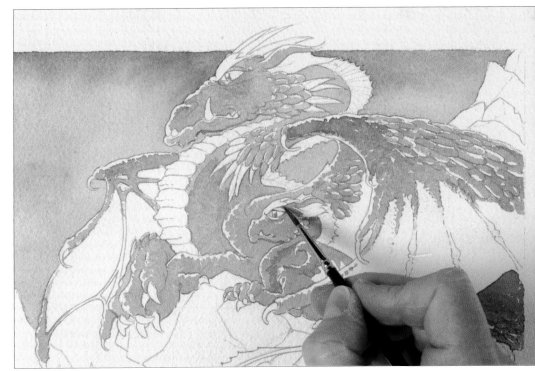

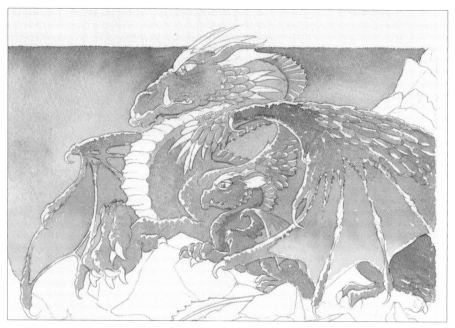

9 Using the size 3 round brush with a mix of raw sienna and alizarin crimson, block in the wing membranes. Add pure water towards the ends of the wings. This fades the colour and makes the wing look stretched. Use the same technique and colour on the crests.

10 With raw sienna and a touch of permanent mauve, paint in the large chest scales and the horn assemblies on the heads, leaving a white highlight on the top left edges as before.

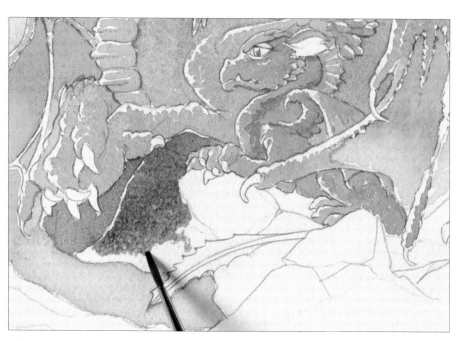

11 Block in the sky under the rocky outcrop with a mix of cadmium orange and gamboge yellow, fading it to pure gamboge yellow on the horizon.

12 Make a permanent mauve and burnt umber mix, with a little raw sienna. Paint in the lighter areas of the rocks, again leaving bare paper highlights to the top left. Drop a cobalt violet and permanent mauve mix in wet-in-wet to vary the tones.

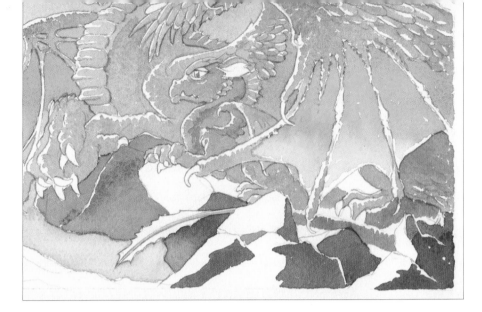

13 Using these mixes, paint in the shaded areas of the rocky outcrop as shown. Dry each area of rock with the hairdryer before moving on to the next. This helps keep the rock shapes distinct from one another.

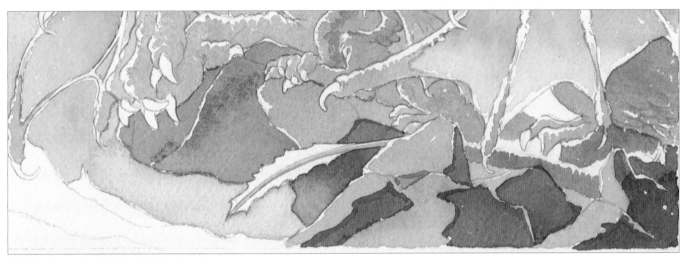

14 Add water to the mixes and paint in the lighter areas of the rocks, varying the tones with a little cobalt violet.

15 Paint in the setting sun with a fairly strong mix of cadmium orange and cadmium red, blended to gamboge yellow at the bottom.

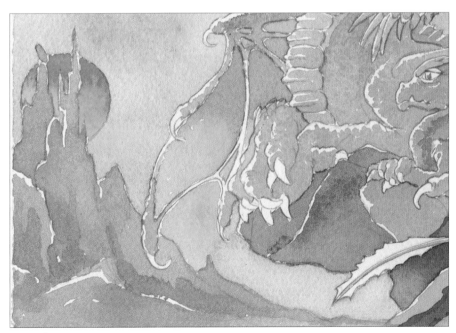

16 Paint in the distant mountains with raw sienna and a touch of permanent mauve. Feed in a little burnt umber to the mix to vary the tones.

17 Paint in the rocks in the top right with lighter mixes of the colours used to paint the outcrop.

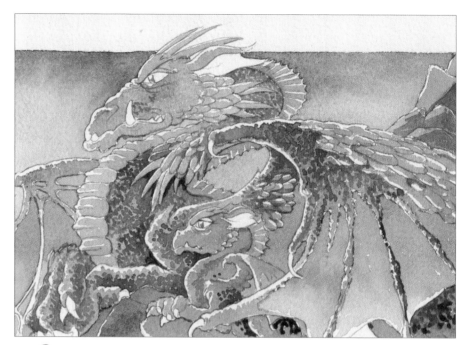

18 Make a strong mix of dioxazine violet, French ultramarine and Davy's gray, and use this to stipple the small scales on the body to provide shading and definition. Allow some to overlap to soften the effect.

19 Switch to the size 2 brush and paint in the smaller scales on the adult's face and the young dragon. Keep the dots close together, allowing the areas to blend.

20 With a stronger mix of ivory black, dioxazine violet and French ultramarine, stipple in the darkest shades to make the areas stand out. Again, allow some of the dots to blend into one another.

21 Still using this mix, paint in the details on the adult dragon's head, lining the larger scales with lines of tiny overlapping dots.

22 Line the mouth with the same mix, then use Davy's gray and Chinese white to shade the teeth and the eye. Paint the pupil and line the eyelid with ivory black.

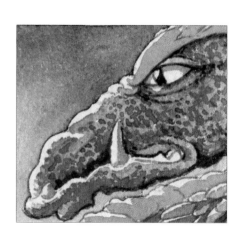

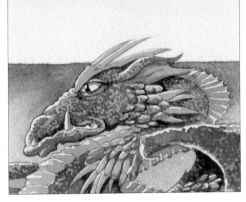

23 Paint the ear with a mix of Chinese white, alizarin crimson and a touch of raw sienna. When dry, shade this with a mix of alizarin crimson

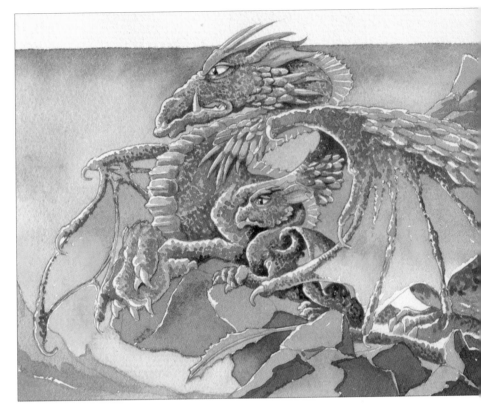

24 Shade the teeth, wing hooks and claws with a mix of Davy's gray and Chinese white. Shade the chest scales and horn assemblies with raw sienna and permanent mauve. Use this mix to paint the tail decoration. Paint in the young dragon's ear and eye as for the adult dragon.

25 Use a mix of dioxazine violet, French ultramarine and a touch of ivory black to paint the darkest shadows in the bottom right.

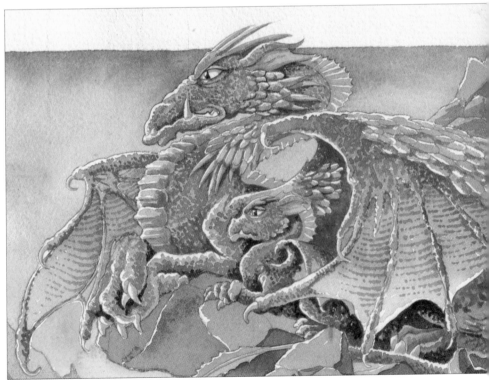

26 Thin down the claw mix from step 24 by adding water, and use it to take the stark edge off the brightest highlights on the feet. Add dioxazine violet to a mix of raw sienna and alizarin crimson, and paint stippled lines on the wing membranes to represent ribbing.

Caring Wing

The finished painting. The title was inspired by the way the adult's wing almost engulfs the offspring like a protective shield. An ivory black and French ultramarine mix has been added to define the outline and the darker recesses. White gouache has also been used for the final highlights.

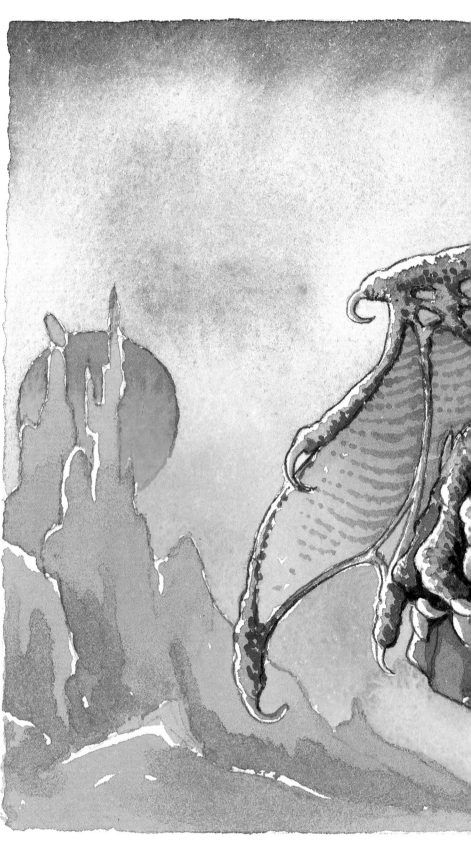

38

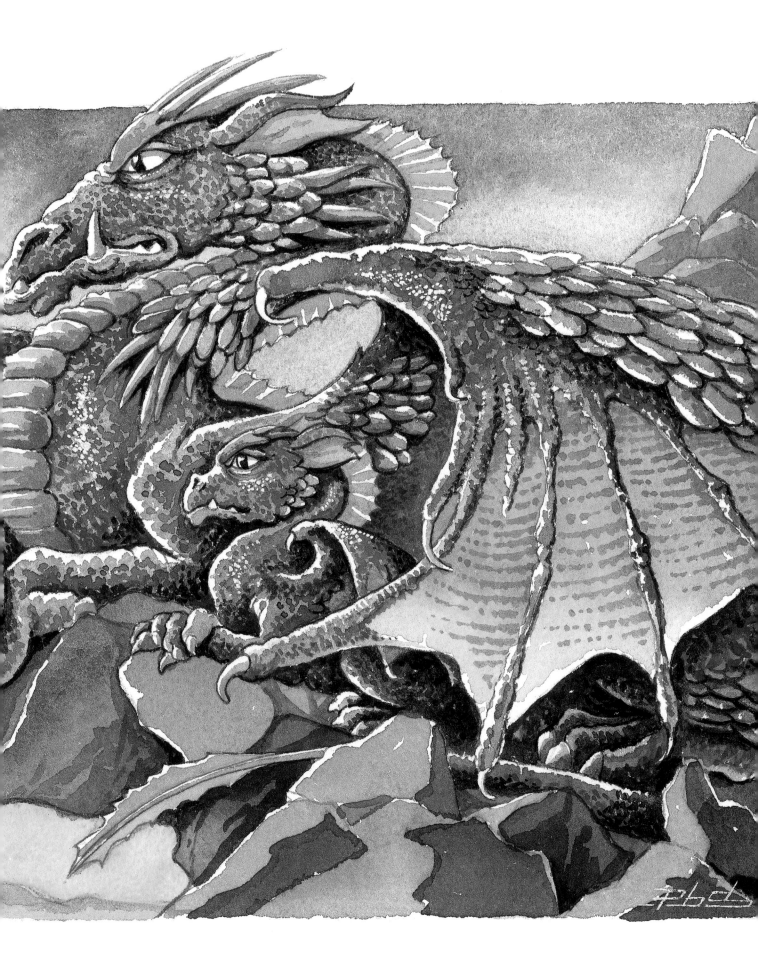

39

Sky Battle

This painting requires patience in the early planning stages as dynamism is the key to creating a sense of excitement in your painting. The background colours have the same tonal values and therefore are almost monochromatic, so as not to 'fight' with the main composition.

YOU WILL NEED

Watercolour paper, 140lb (300gsm) NOT finish

Tracing paper

Printer paper

Hairdryer

HB pencil

B pencil

H pencil

Ballpoint pen

Burnishing tool

Brushes:
 Size 0 sable, size 00 sable, size 1 sable, size 2 sable, size 3 round, size 6 round

Paints:
 Hooker's green, Davy's gray, yellow ochre, Chinese white, burnt umber, Winsor green, French ultramarine, dioxazine violet, rose madder, purple madder, Prussian blue, ivory black, cadmium red deep, gamboge yellow, white gouache

1 Sketch in the rough shapes with the HB pencil. This composition is more complex than the previous demonstration, so take your time to make this rough sketch a little more detailed to help you later on.

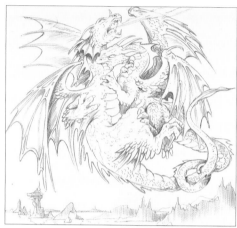

2 Add detail to the picture with the HB pencil. Once you are happy with it, go over the lines with the ballpoint pen.

3 Lay a sheet of tracing paper over the picture and use the H pencil to trace the picture. Flip the paper over and use the B pencil to trace it on to the other side. Flip once more and place the tracing over your watercolour paper. Transfer it with the burnishing tool.

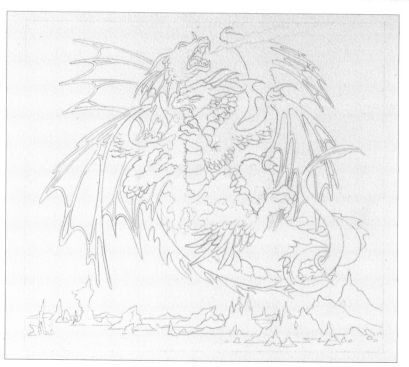

4 Using the size 1 sable brush, paint a thin wash of Hooker's green to outline the left-hand dragon and Davy's gray for the right-hand dragon.

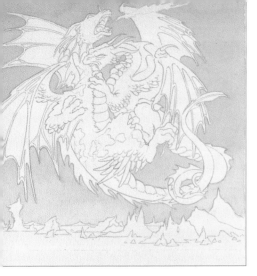

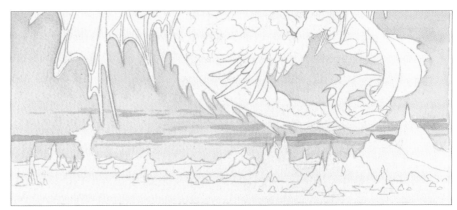

5 Paint the sky with the size 6 round and a mix of yellow ochre and Chinese white, starting from the top and fading towards the horizon.

6 Add burnt umber to the sky mix and use the size 2 brush to lay in some cloud formations on the horizon.

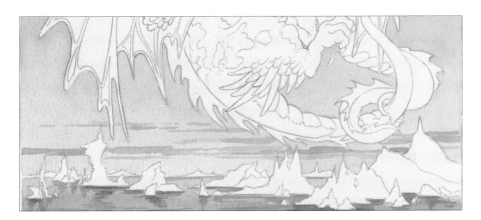

7 Use the cloud mix to paint in the sea between the rocky outcrops. Strengthen this wet-in-wet with a little more burnt umber at the bottom of the sea. Add reflections with the stronger mix wet-on-dry. Remember that closer reflections are darker than more distant ones.

8 Mix burnt umber with Chinese white. Use the size 2 brush to paint in the rocky outcrops, leaving highlights on the left-hand sides. Use a weaker mix to block in the distant mountains on the horizon.

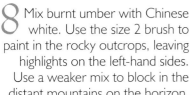

9 Use yellow ochre and Chinese white to paint in the light areas on the rocky outcrops, leaving a little bare paper showing through at the extreme highlights. Add burnt umber to the mountain mix and use this to define and shade the rocky outcrops.

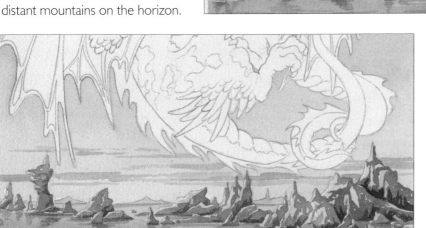

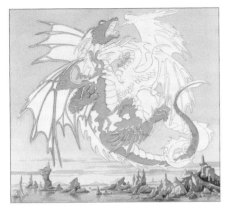

10 With a Winsor green and yellow ochre mix and the size 3 brush, carefully paint the green dragon, remembering to leave white areas where the large scales catch the light, as well as on the piebald areas.

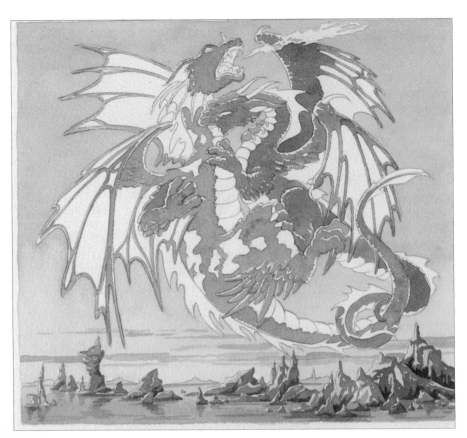

11 Mix Davy's gray and French ultramarine and wash in the right-hand dragon, again leaving white highlights.

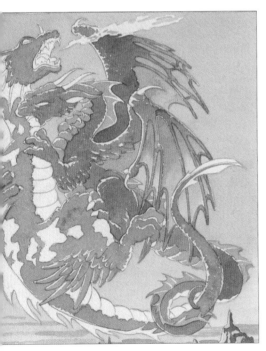

12 Use a dioxazine violet, Chinese white and rose madder mix for the grey dragon's wings. Add water to the mix at the edges to fade the colour as shown. Use this same mix to paint the crest and chest scales.

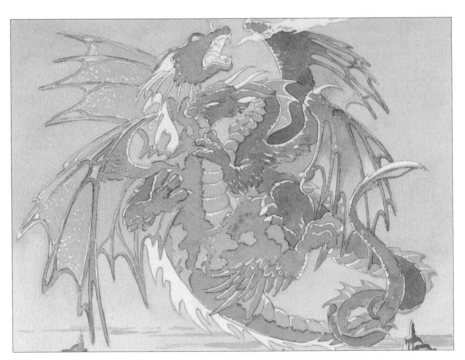

13 Paint the green dragon's wings and chest scales with a mix of purple madder, Chinese white and a touch of yellow ochre. Leaving dots of white paper showing through gives a different texture when compared to the grey dragon's wings. Use the same mix to paint the frill around the neck, leaving the supporting spines white as shown above. Stipple in the piebald patches on the body using the technique for small scales on page 10.

14 Using a stronger version of this mix, shade the crest and tail decoration of the green dragon wet-on-dry.

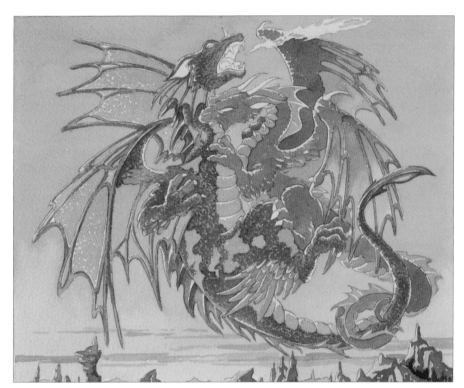

15 Add Winsor green to the green dragon's skin mix, and stipple darker scales to shade and define the body. Use the same mix to paint the frill spines and line the wings.

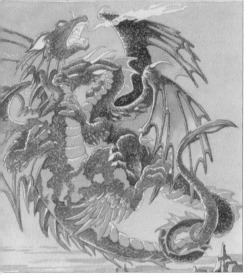

16 Paint in the dark scales on the grey dragon with a Davy's gray and French ultramarine mix with a touch of dioxazine violet.

17 Use this mix to paint the teeth and claws on both dragons. Water it down to take the harshness out of the stark highlights on the grey dragon, and shade the eyes.

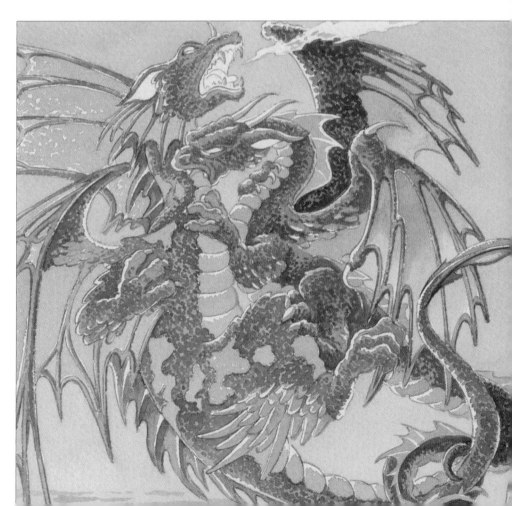

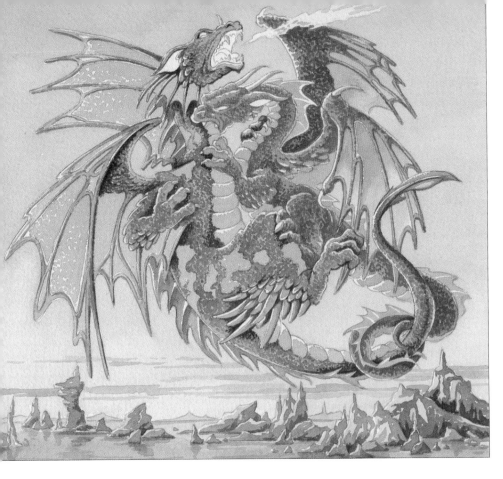

18 Add Prussian blue to the green dragon's skin mix and shade the large scales, following the steps on page 11. Add more Prussian blue to the mix and define the dark areas with a mix of stippling and line work. Pay particular attention to the area where the grey dragon is biting the green dragon's neck to emphasise this point.

19 Shade the green dragon's wings by stippling with a Chinese white, purple madder and yellow ochre mix. Repeat this on the frill, underbelly and piebald patches.

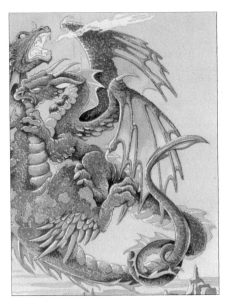

20 Shade the grey dragon's body using a Prussian blue, ivory black and Davy's gray mix.

21 Shade the grey dragon's wings using dioxazine violet and ivory black. Switch to the size 0 brush to paint veins on the wings as shown in the inset.

44

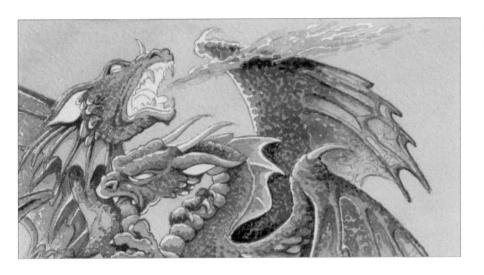

22 Paint the flame following the steps on page 10.

23 Paint the insides of the ears with a cadmium red deep, gamboge yellow and Chinese white mix. Use the same mix for the inside of the green dragon's mouth and tongue. Add purple madder for the darker areas. Still using the size 0 brush, add dioxazine violet for the very deepest shades, and highlight with white gouache to give a wet effect.

24 Use ivory black straight from the tube to paint the pupils on both dragons. The grey dragon's pupil must point towards the green dragon's neck, while the green dragon's pupil must be rolling back in pain. Detail the eyes and nostrils with watered-down ivory black, and highlight the pupils with white gouache.

45

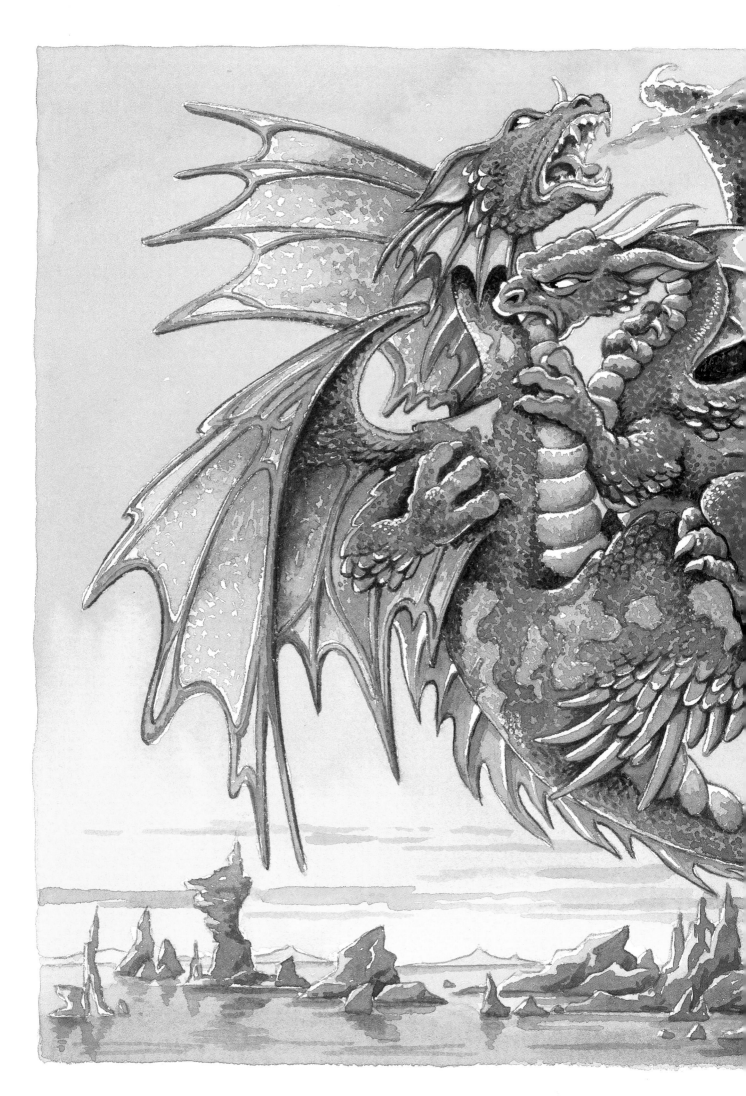